Renoir

Luncheon of the Boating Party

For example, the model for the bare-armed man straddling his chair in the foreground on the right, a cigarette pinched between his thumb and forefinger, is traditionally identified as the painter Gustave Caillebotte (1848–94), although the resemblance is not obvious. Son of a manufacturer of blankets and beds for the French army, Caillebotte inherited a fortune in 1874. Accomplished and rich, he exhibited with the impressionists, underwrote their exhibitions, and bought many of their works. One of Renoir's close friends, Caillebotte was godfather to Renoir's oldest son, Pierre, and designated Renoir to be executor of his will. Caillebotte bequeathed a considerable collection of impressionist paintings (including at least eight by Renoir) to the nation. As executor, Renoir negotiated the entrance of Caillebotte's collection into the Musée du Luxembourg, the museum of contemporary art at that time.

Caillebotte ranks as one of the most important French yachtsmen of the nineteenth century. His family's property southeast of Paris, near the river Yerres, gave him the opportunity to spend many summers there boating. In 1881, after the sale of the Yerres estate, Caillebotte and his brother Martial bought riverside property at Petit-Gennevilliers, across from Argenteuil, in order to have more time to sail. After Martial married in 1887, Gustave settled permanently at Petit-Gennevilliers and devoted himself to sailing and gardening. Winner of numerous sailing trophies, Caillebotte published technical articles in *Le Yachting* and served as president of the Paris yacht club, le Cercle de la Voile de Paris. So great was his enthusiasm for yachting that a year after Renoir painted the *Luncheon of the Boating Party*, Caillebotte began designing his own sailing boats and eventually built a boat yard at Petit-Gennevilliers.

Renoir's Friends

WHO ARE THESE lucky, convivial people? A mixed group, the men outnumber the women almost three to one, although it's the women who dominate the painting. Nobody at this party seems boring or bored and nothing signals the presence under foot of restive, whining children. Improbably, wishfully, everyone on the balcony (at least everyone whose face is visible) is young and good-looking. In an important sense, they are just fourteen people out for the day. At the same time, their highly individualized faces are reminders of Renoir's skill and success as a portrait painter, and in fact their identities are known.

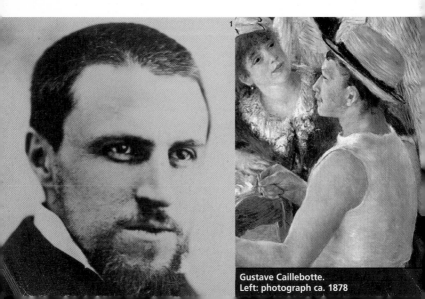

Gustave Caillebotte.
Left: photograph ca. 1878

Contents

Introduction

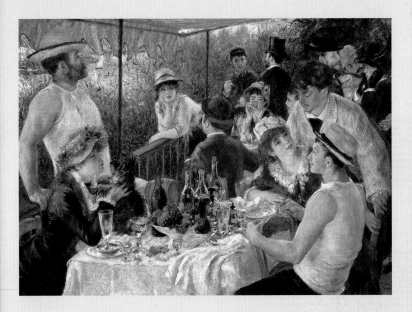

PIERRE-AUGUSTE RENOIR's *Luncheon of the Boating Party*,
1880–81 (The Phillips Collection, Washington, D.C.), pays tribute
to a perfect moment of golden happiness and good fellowship.
The meal is over; the party, however, continues. A band of pretty
young women and a tousled lap dog, surrounded by attentive
men, visibly enjoy the company, place, and weather, on a glorious
afternoon in late summer. Gathered around two tables on a
riverside restaurant's verandah, the boating party drink, smoke,
flirt, and chat; some are still seated, others stand in little groups.

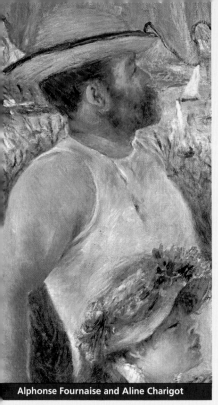

Alphonse Fournaise and Aline Charigot

Across the table from Caillebotte sits a pretty young woman with a dog. The model was Aline Charigot (1859–1915), a seamstress from Essoyes in the Champagne region, southeast of Paris. Renoir met her around 1880 and a decade later they married. She bore him three sons, Pierre (1885), Jean (1894) who became a famous filmmaker, and Claude (1901). In his amusing book *Renoir, My Father*, Jean noted his father's preference for plump women. "He liked small noses better than large ones, and he made no secret of his preference for wide mouths, with full, but not thick, lips; small teeth; light complexions; and blond hair." Eventually Aline became very stout. Photographs of her and Renoir in later life recall Jack Sprat and his wife. But here, Renoir portrays her slender and childlike, engrossed coquettishly with the bright-eyed little dog perched on the table (the French indulge their dogs). During World War I, when Jean and Claude were wounded, Aline rushed between the two hospitals where they were being treated. The resulting exhaustion weakened her and she died of a heart attack in 1915. Behind Aline, leaning against the railing stands Alphonse Fournaise (1848–1910), son of the proprietor of the Maison Fournaise at Chatou, where the lunch party takes place. Like Caillebotte in the foreground, he is dressed for rowing in a tight tank top and a straw hat.

Who's who!

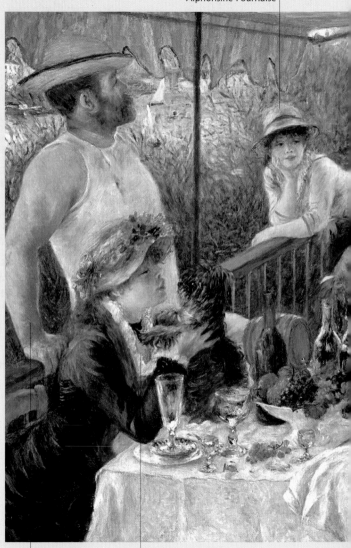

Alphonsine Fournaise

Alphonse Fournaise

Aline Charigot

Further along the railing, a sweet-faced young woman talks to a man in a brown bowler hat. She has been identified as Alphonsine Fournaise (1846–1937), daughter of the restaurateur. The model for the man, his back to the viewer, was Baron Raoul Barbier, Renoir's friend. Barbier, the

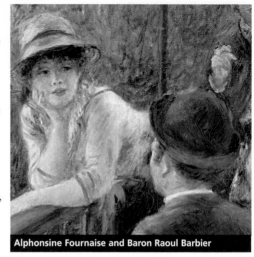

Alphonsine Fournaise and Baron Raoul Barbier

son of the French ambassador to Constantinople. was a cavalry officer. He held the position of mayor of Saigon during the first years of the French occupation of Indochina. He returned to France from the Far East in 1876, left the army, and fell on hard times, living on a small allowance from his mother. This doesn't seem to have cramped his style. The baron liked women and haunted the backstages of Montmartre's theaters, including the Folies-Bergère. A regular patron at the rowdy riverside bathing establishment and restaurant known as La Grenouillère, located at Bougival, near Chatou, he first met Renoir at La Maison Fournaise.

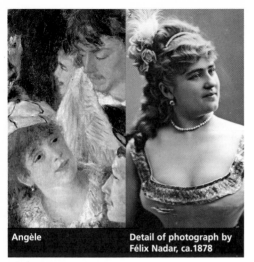

Angèle

Detail of photograph by Félix Nadar, ca.1878

The fair-haired sitter in the white and blue toque has been identified as the actress Angèle. A man bends over her attentively, his arms encompassing her and the figure of Caillebotte with a gesture of relaxed familiarity. He bears the likeness of Maggiolo, an Italian journalist who worked for the weekly satirical magazine *Le Triboulet*. The magazine published commentaries on theater and cabaret performers, which may explain why Renoir posed this particular couple together.

Another well-known actress, Ellen Andrée, is seated at the neighboring table, a glass raised to her lips. Like many of the other sitters in this painting, she posed more than once for Renoir, as well as for other impressionist painters.

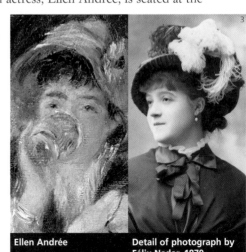

Ellen Andrée

Detail of photograph by Félix Nadar, 1879

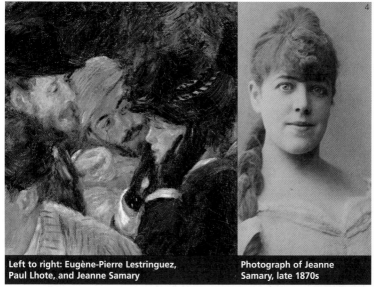

Left to right: Eugène-Pierre Lestringuez, Paul Lhote, and Jeanne Samary

Photograph of Jeanne Samary, late 1870s

The last group, standing at the right rear of the canvas, includes a bearded man seen in profile, identified as Eugène-Pierre Lestringuez, an official in the Ministry of the Interior, who appeared in other paintings by Renoir. Lestringuez dabbled in the occult and practiced hypnosis, according to Jean Renoir's account of the Lestringuez household, which he knew well as a child. The man to the right in a straw hat and pince-nez is Paul Lhote. He and Lestringuez were close friends of Renoir and were witnesses at his marriage to Aline. In 1881, they accompanied the artist during his visit to Algeria. Clapping her hands over her ears to shut out either the two men's flirtatious comments or the sound of a starting pistol for a boat race (or, perhaps, just adjusting her hat), is the famous Comédie-Française actress Jeanne Samary. She may have met Renoir at the Charpentier's salon and appears in other paintings by him. At the time of the *Luncheon of the Boating Party* she had recently become engaged. The hint of a top hat at the extreme right edge of the painting and the hand around her waist may indicate the presence of her fiancé.

The two men conversing in the far-left corner of the balcony offer a study in contrasts. The bearded figure in the top hat is Charles Ephrussi (1849–1905), a Russian-born art collector and writer who came to Paris in 1871. Editor of the *Gazette des beaux-arts*, Ephrussi became the

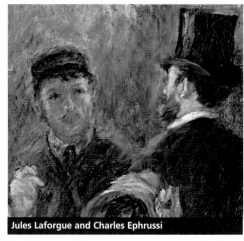

Jules Laforgue and Charles Ephrussi

periodical's owner in 1885. Although his interest centered on Italian Renaissance art, especially drawings, he also championed the impressionists. Between 1879 and 1881 he bought a significant number of paintings by Claude Monet, Edouard Manet, and three by Renoir. Ephrussi promoted the impressionists to members of his family, encouraging them to buy works, and, on occasion, chose works for them himself. Through Ephrussi, Renoir received important portrait commissions from the Cahen d'Anvers family. At the time of the *Luncheon of the Boating Party*, one of Ephrussi's friends, Charles Deudon, was supporting Renoir financially. In July 1881 Ephrussi hired, as his secretary, Jules Laforgue (1860–87), a young French poet and journalist for *La Vie moderne* published by Georges Charpentier, one of Renoir's most important patrons. Ephrussi had a considerable influence on Laforgue, introducing him to modern art and helping him to become an important critic. Based on a comparison with other portraits, Laforgue was almost certainly the model for the man in a brown jacket and cap, holding a cigarette and conversing with Ephrussi.

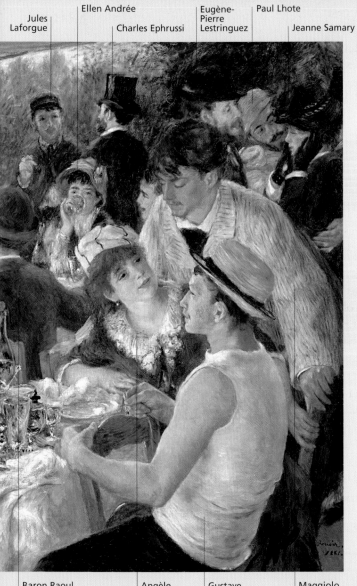

Jules
Laforgue

Ellen Andrée

Charles Ephrussi

Eugène-
Pierre
Lestringuez

Paul Lhote

Jeanne Samary

Baron Raoul
Barbier

Angèle

Gustave
Caillebotte

Maggiolo

The Artist

Pierre-Auguste Renoir, 1870s

BORN IN LIMOGES on February 5, 1841, Renoir moved with his family to Paris when he was three. There, he grew up, his father a tailor and mother a seamstress.

From 1854 to 1858 Renoir apprenticed as a painter on porcelain, an occupation with roots in the ancien régime of the eighteenth century. From around 1858 to 1859 he painted decorations on blinds. Both occupations contributed to his skill as a painter. Painting on porcelain involved making copies of Sèvres ceramics, which inevitably made Renoir sensitive to the decorative traditions of the rococo. This taste corresponded to a fashion for the rococo in textiles, furnishings, and dress that lasted for about twenty years from 1860. Visits to the Louvre during his lunch break taught him to love the work of eighteenth-century painters such as Antoine Watteau, François Boucher, and Honoré Fragonard. In 1860 Renoir received permission to copy paintings in the Louvre. The following year he began formal training as a painter in the studio of Charles Gleyre, where he remained until 1864. From 1862 Renoir pored over drawings at the Ecole des beaux-arts in the evening. Although he believed the key to learning how to paint was to look at paintings, he held a high regard for his teacher Gleyre, at whose studio he met painters who later were to become his friends and fellow founders of the impressionist movement: Claude Monet, Alfred Sisley, and

In some respects Renoir was an unlikely impressionist. For one thing, although he painted many pictures out-of-doors, he was primarily a studio painter whose main subjects were figures and portraits. For another, he felt uneasy with many aspects of modern society. Comments to his son Jean reveal an attitude full of ambivalence, if not outright hostility. The painter of happy, hedonistic images, Renoir, in fact, was by nature a worrier, whose anxieties about his children's welfare are well documented by his son. He seems also to have been uncomfortable about his own place in society. By abandoning the world in which he had apprenticed and training as a painter, Renoir left the class of his birth and moved up the social ladder, joining the middle class. Like many craftsmen, Renoir possessed a Luddite streak, and he expressed views that bordered on the reactionary. Perhaps his preoccupation with rococo painting reinforced a perspective of the modern world as difficult and disappointing.

Predominantly a figure painter, Renoir loved female beauty. Women make up the majority of his subjects. He made love, he once said, with his brush. He had no time for modern notions of women as educated or professionally ambitious. Instead, his paintings picture them as essentially childlike, uncomplicated, and natural beings. His

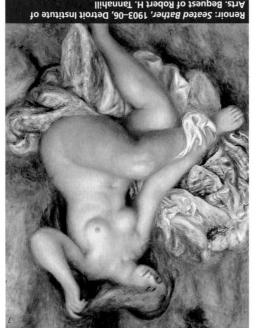

Frédéric Bazille, with whom he shared a studio in 1867 and 1868.

Renoir first exhibited at the Paris Salon in 1864 and again in 1865. He took part in the 1873 Salon des refusés, and the first impressionist exhibition of 1874. Exhibiting in the second and third impressionist exhibitions (1876, 1877), he then did not show with them again until the seventh exhibition in 1882. *Luncheon of the Boating Party* was one of twenty-five paintings he showed on that occasion.

Renoir's life changed around the time he painted *Luncheon of the Boating Party*. Not only did he meet his future wife Aline Charigot, but he also began to have some financial success, in part because of the portrait commissions he received from wealthy Parisians. In 1883 Paul Durand-Ruel, his dealer for the preceding decade, gave him his first solo exhibition. During this period, the early 1880s, Renoir traveled to Italy, Algeria, and the south of France. Five years after the birth of his first son in 1885, Renoir married Aline. Having lived virtually his entire life in Paris, Renoir began spending time in

Renoir and Aline, ca. 1900

Essoyes, his wife's childhood home. In 1908 the Renoir family moved to a house at Les Collettes, at Cagnes-sur-Mer on the Mediterranean. In 1904 the Salon d'Automne exhibited thirty-five of his paintings. By then, Renoir was deformed and crippled by arthritis. Yet, he worked to the end, his brushes taped to his hands. With the aid of a collaborator, Richard Guino, the painter took up sculpture. Renoir died in 1919 at Cagnes.

women, echoing the female denizens of rococo paintings, almost always have childish flesh and faces, plump round bosoms and bottoms, and short legs.

Renoir's love of eighteenth-century art may also have made him more aware of the depressing aspects of modern life, but at the same time it helped him transcend it by providing a kind of painterly escapism. Renoir cast his young

Renoir: *The Loge*, 1874, Courtauld Institute Galleries, London. The sumptuous costume transformed the model, Nini, from working girl to rich bourgeoise

working-class models in the guise of elegant young ladies, modern goddesses, and transformed the shabbiness of Montmartre's public spaces into magical, arcadian parks. His trip to Italy, Algeria, and the south of France in 1881 caused a change in his art and renewed his awareness of the old masters and the art of antiquity. He began to turn away from modern subject matter. Feeling that he had reached a crisis in his art, he decided that he knew neither how to draw nor paint and set about re-educating himself, particularly as a draftsman, introducing new linear qualities into his work, and concentrating more and more on the female nude in natural settings (such as *Seated Bather*, shown left). However, by the end of the decade his light touch and interest in color had reasserted themselves. With his move to the south of France, Renoir stopped trying to paint his way around contemporary urban problems as he grappled with ideas of timelessness instead of fleeting moments of relaxed conviviality.

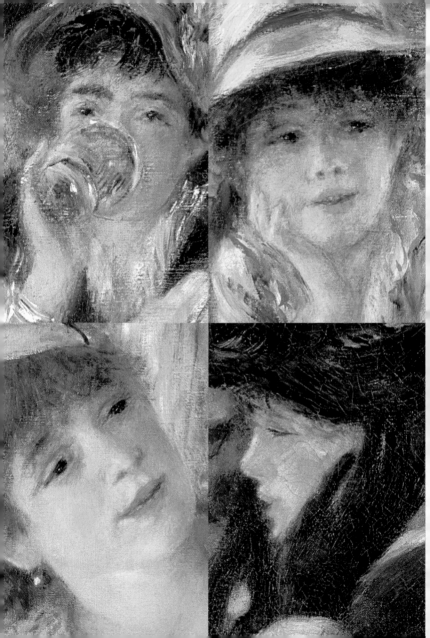

The bridge, Chatou, late nineteenth century

suburbs. In fact, the railroad companies themselves sponsored many of the leisure activities that attracted Sunday crowds. Working Parisians not able to live in the new suburbs spilled out of the city on Sundays to frolic along the Seine. For the price of a cheap roundtrip ticket, working people could board trains at the Gare Saint-Lazare and escape to places like Argenteuil, Asnières, Bougival, and Chatou. In the upper left quadrant of his painting, within the scallops of the red and white awning, Renoir includes the railroad bridge at Chatou, a reminder of how this boating party arrived at the restaurant and how its members will return to the city at the end of the day.

Out in the suburbs, city dwellers could amuse themselves in any number of ways: enjoy a picnic or eat in restaurants and cafés, rent

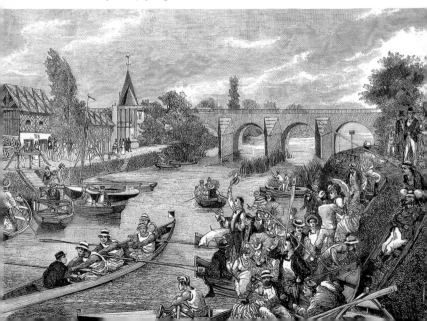

Today, we take our weekends for granted. In the second half of the nineteenth century, middle-class Frenchmen had just begun to consider vacations away from the city as desirable and necessary. However, they were not available to everyone. In France even the six-day workweek was not legislated until early in the twentieth century, although it was in effect in the late nineteenth century, while the paid vacation did not become a reality until 1936. When Renoir painted *Luncheon of the Boating Party*, French workers endured brutal twelve-hour days and were free only on Sundays. Many city dwellers lived in dark, cramped apartments. With the advent of the railroad, it became possible to get away, if only for a day, to enjoy fresh air, greenery, and some respite from the congested and unsanitary conditions of Paris. At the same time, the development of the railroad in the first half of the nineteenth century fueled the transformation of outlying villages into Parisian

Life on the river outside Paris, 1877

Leisure

Was this luncheon *al fresco* a special occasion? There is no reason to think so. In the painting's background, beyond the restaurant's striped awning and just visible through the willow leaves, Renoir gives us a glimpse of the river Seine

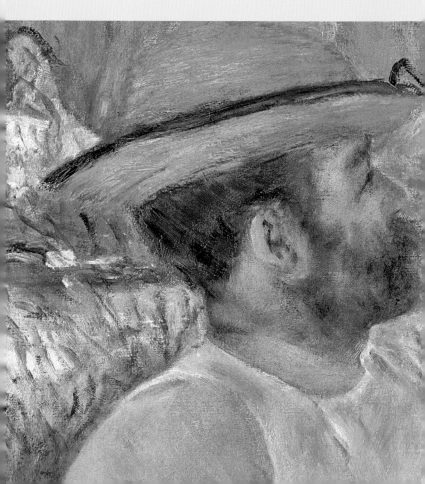

and its far bank. The silvery blue brilliance of sunlit water exerts a strong pull on the viewer's gaze. Although the work's composition emphasizes human communion, there is no mistaking the fact that the luncheon's balcony setting faces the river. The party is here because the river is here. In Renoir's day its banks were synonymous with leisure.

Luncheon of the Boating Party, overcrowded Asnières gave way to Chatou as the place to row. In the 1860s Renoir and the other impressionists began visiting and painting the vacation spots along the Seine. Caillebotte owned a house at Petit-Gennevilliers. Edouard Manet's family had one at Gennevilliers. Berthe Morisot's family rented a summer home at Bougival, while Alfred Sisley resided in Louveciennes and later at Marly-le-Roi. Claude Monet lived at Argenteuil, and Renoir, whose mother had her home nearby, at Louveciennes, visited Chatou throughout the 1870s. Renoir cast the Fournaise restaurant as the setting for several of his paintings and counted its owners among his friends.

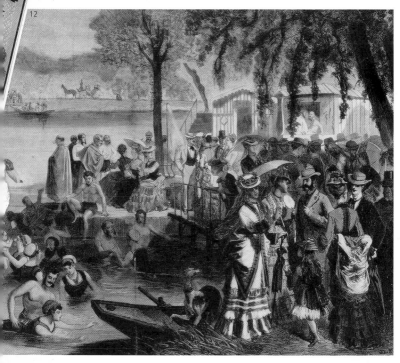

dance, ca. 1890. Above: Dominique Yon, engraved by Miranda, *La Grenouillère*, 1873

cabins, fish, squeal and giggle as they learned to swim, wearing rented costumes, at bathing resorts like La Grenouillère at Bougival, make new friends, dance at dance halls, and stroll. They could also flirt. Resorts built during the nineteenth century quickly assumed amatory associations, witness the attitudes of easy intimacy displayed by the members of Renoir's boating party. The greatest escapes were provided by boating. Recreational rowing and sailing were amusements imported to the Seine from England, along with industrialization, the railroad, and a special anglicized vocabulary that included terms like 'le yachting'. By mid century boating became a common activity on the Seine, with regattas and clubs, including a sailing club at Argenteuil and a rowing club at Asnières. Although membership in these was limited to the rich, who could afford to own their own boats, less-well-off people could, and did, rent boats. By the time Renoir painted the

Top: Poster advertising a boaters'

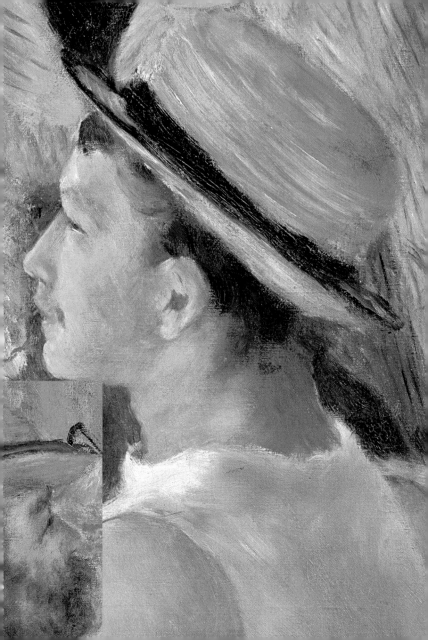

For their part, Baron Barbier and Lestringuez are dressed sportingly, though not for boating. The baron has on a brown jacket and a small, brown bowler. Lestringuez's outfit is not visible, but like the baron he dons a felt bowler. Maggiolo's costume matches the informality of his gestures. He is bareheaded, as is the unidentified person whose face appears between his shoulder and Ellen Andrée.

Caillebotte, the Fournaises, and Lhote all sport woven-straw sun hats that boaters typically wore. Caillebotte's flat boater with its dark ribbon around the crown alludes to his membership in the Paris yacht club. The high-crowned type worn by the others was basically a unisex model, often worn by gardeners and peasants, and could be worn with the brim up or down. Its informality, echoed in the sleeveless rowing shirts worn by Alphonse Fournaise and Caillebotte, demonstrates how

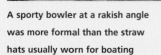

A sporty bowler at a rakish angle was more formal than the straw hats usually worn for boating

The Hats

ALMOST EVERYONE IN the painting is wearing a hat. Renoir, according to his son Jean, insisted that his family wear hats to guard against the sun. The range of formality of the headgear and other clothing suggests a democratized mingling of social classes around leisure pursuits in nineteenth-century France and serves as a kind of shorthand for up-to-date modernity.

As the novelist Marcel Proust (1871–1922) noticed, not everyone is dressed for boating. He was particularly struck by the juxtaposition of Ephrussi's top hat with Laforgue's yachting or possibly student cap. Proust met Ephrussi around 1896 and began working in the library of the *Gazette des beaux-arts* in 1900. There, he learned about art. It was probably in the company of Ephrussi that Proust saw an exhibition of impressionist painting at Durand-Ruel's gallery in 1899. In it was Renoir's *Luncheon of the Boating Party*. Proust's experience of seeing the painting resurfaced in *The Guermantes Way*. In the collection of the Duc de Guermantes, the character Marcel sees a painting by Elstir, a fictional painter who was based in part on Renoir. He asks about a person dressed incongruously in a frockcoat and tall hat "at some popular seaside festival where he had evidently no business to be." M. de Guermantes responds: "What I can tell you is that the gentleman you mean has been a sort of Maecenas to M. Elstir – he launched him and has often helped him out of difficulties by commissioning pictures from him. As a compliment to this man – if you call it a compliment, it's a matter of taste – he painted him standing about among that crowd, where with his Sunday-go-to-meeting look he creates a distinctly odd effect. He may be no end of a pundit but he's evidently not aware of the proper time and place for a top hat."

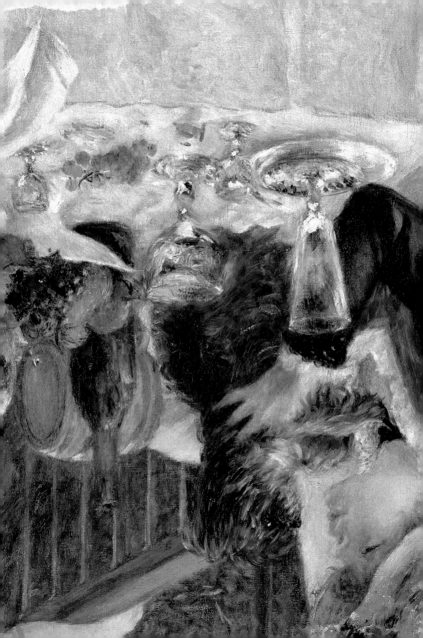

La Maison Fournaise

THE BOATING PARTY takes place at La Maison Fournaise. In 1857 Alphonse Fournaise bought his cousin's building next to the old Chatou road-bridge, now destroyed.

The railroad to Chatou had opened in 1837, and Fournaise, who came from a family of ship carpenters and watermen, saw a commercial opportunity in catering to the crowds that began to arrive there from Paris on Sundays. He organized water tournaments and set up a business renting out punts and skiffs, adding a restaurant and hotel in 1860. As the bathing station and restaurant at La Grenouillère, a short distance away at Bougival, became more and more crowded, people discovered La Maison Fournaise. It became a favorite haunt for artists

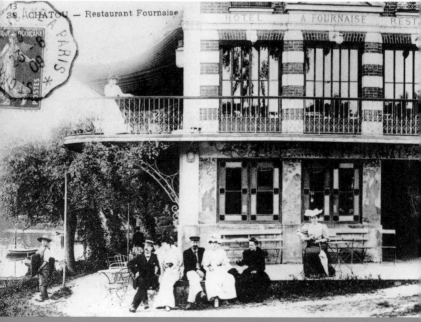

Postcard view of La Maison Fournaise, Chatou, late nineteenth century

The Still Life

WHAT WAS ON the lunch menu we do not know because the moment Renoir chose to capture in the *Luncheon of the Boating Party* came after the meal's conclusion and the dishes were cleared. Some green-gold pears and grapes of black and gold in a footed fruit bowl, a bunch or two discarded on the table, are all that remain of the meal itself, apart from the wine that continues to flow.

The effect, however, of Renoir's still life in the painting's foreground indicates it was a feast-like repast well worth the train ride from Paris. In spite of the absence of items one might expect to find in a painting with the word luncheon in its title—crusty bread, cheese, a knife, perhaps, with its handle artfully angled towards the viewer—the result is opulent. Renoir achieved a sense of staggering indulgence simply by showing the snowy tablecloth littered with glasses and half-empty bottles, crumpled napkins, a few plates, a spoon, and a small cask, perhaps for brandy. Renoir evoked the moment in the accumulation of details: gleaming reflections on green-tinted wine bottles and an assortment of glasses, pearly glints of crockery, and table linen sumptuously disheveled like a bed after a night of love.

sporting activities loosened people up. Aline Charigot and Angèle at the first table and Andrée at the one beyond wear blue flannel dresses typically worn by women out for a day rowing. Charigot and Andrée have on straw hats similar to those worn by the Fournaises and Lhote, but with trimmings of artificial flowers made of silk. Poor

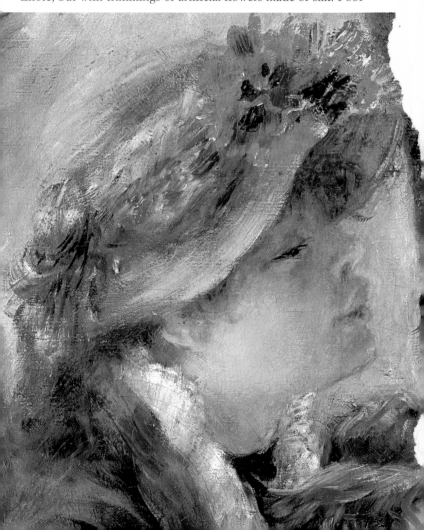

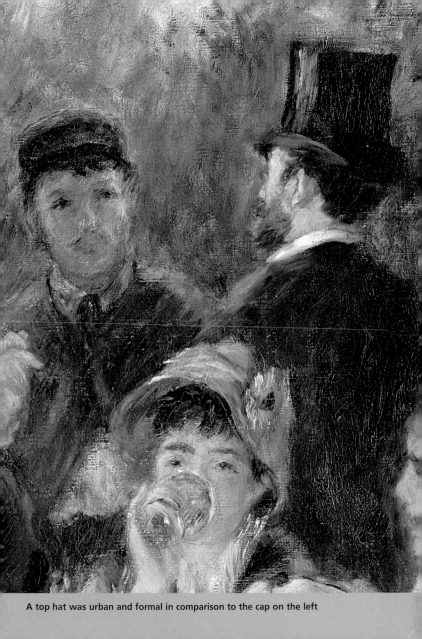
A top hat was urban and formal in comparison to the cap on the left

young women in exchange for very meager wages made these in sweatshops for sale to milliners. As befits actresses, Angèle and Jeanne Samary wear hats that seem more glamorous than those worn by the other women. Angèle's toque is decorative rather than utilitarian, although its colors, white with blue stripes, give it a slightly nautical air. Samary's hat is essentially the same shape as Marigot's, but its darker color and her gloves suggest a slightly urban chic. Perhaps, she is about to leave the party and head back to town.

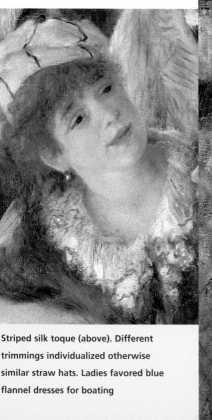

Striped silk toque (above). Different trimmings individualized otherwise similar straw hats. Ladies favored blue flannel dresses for boating

and writers. In 1877 Fournaise added a terrace and balcony, the setting for Renoir's *Luncheon of the Boating Party*. His wife ran the kitchen. Their children, seen in the painting, worked too. Their son, Alphonse, helped ladies on and off the boats, and their daughter, Alphonsine, acted as receptionist, as well as modeling for painters. A good swimmer, she entertained guests by diving for coins. Edgar Degas was a witness at her wedding. Alphonse *fils* took over the operation in 1890 and ran it until his death ten years later, when there was a decline in the boat business as bicycling became more popular. Alphonsine continued to run the restaurant until 1905. After that she took in lodgers until her death in 1937. She left both businesses to cousins. In 1953 La Maison Fournaise was sold and became an apartment building. After it fell into disrepair, the town of Chatou bought it in 1979 and restored it.

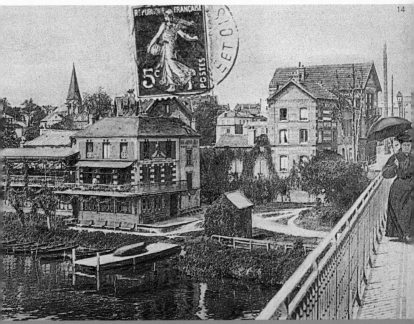

Postcard view of La Maison Fournaise from the Chatou road-bridge, showing the rental boats and jetty, late nineteenth century

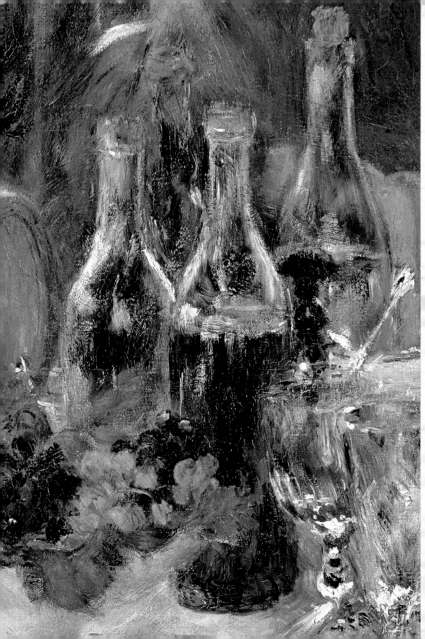

landscape, still life, portraiture, and a moment of everyday modern life.

Although he finished the painting in his studio, Renoir executed a great deal of it in Chatou where the artist must have expended considerable energy managing the comings and goings of his many sitters. The painting took him far longer than he

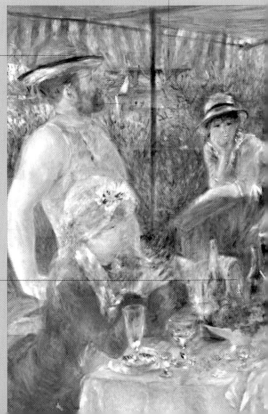

Renoir developed the landscape and included the whole span of the railroad bridge before covering them with the striped awning. He added the awning to strengthen the illusion of depth in the composition.

Renoir repositioned Alphonse Fournaise's hat several times.

A wine glass in front of the cask was painted out. The bunch of grapes at the front of the table is painted over an aperitif glass. Renoir also painted out a wine glass that stood in front of the fruit bowl.

An infra-red reflectogram of the painting

Some of the impetus for Renoir's painting may have come from the critic Emile Zola (1840–1902). In 1880 he challenged the impressionists to create complex paintings of modern life that resulted from "long and thoughtful preparation" and that would establish "a new formula." Renoir's response came in a work that can be viewed as a summary of impressionism, combining as it does,

Beneath the surface of
Luncheon of the Boating Party

Renoir seems to have composed the painting without studies or underdrawing. The sitters may never have all assembled at one time. As a result the painter had to make many adjustments in their positions as he went along. Most changes were made to develop the interactions among the members of the party. The creation of an enclosing space was another significant compositional challenge. Technical examinations of the painting have made many of Renoir's earlier choices visible.

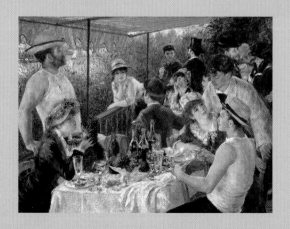

The Making of a Masterpiece

IN 1880, WHILE occupied with painting the *Luncheon of the Boating Party*, Renoir wrote: "*I am at Chatou I'm doing a painting of oarsmen which I've been itching to do for a long time I didn't want to defer this festivity One must from time to time attempt things that are beyond one's capacity.*"

Even without such evidence, the painting itself declares his ambition. Far larger than most impressionist pictures, on a scale more typical of the submissions to the annual Paris Salon, *Luncheon of the Boating*

Paolo Veronese, *The Wedding at Cana*, 1562–63, Musée du Louvre, Paris

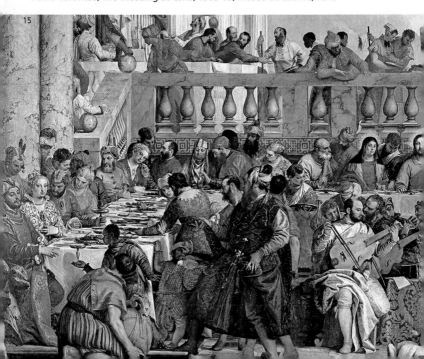

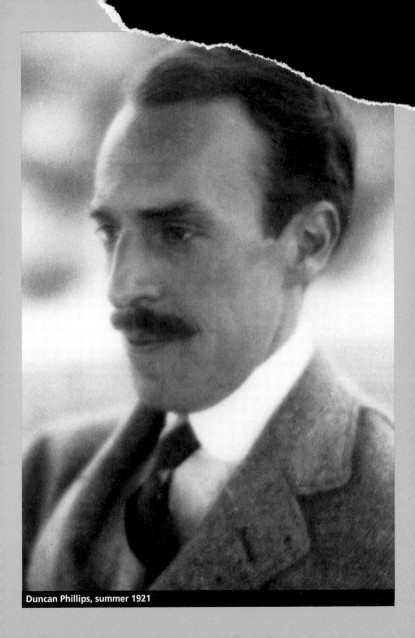
Duncan Phillips, summer 1921

...emorial Gallery, late 1920s. Paintings nearby include wo...

The house at 1600 Twenty-first Street. N...

negotiations and by July 9 he and Joseph Durand-Ruel struck a deal.
The next day Phillips wrote to the treasurer of the Phillips
Memorial Art Gallery that it was to be the possessor of "one of the
greatest paintings in the world. The Déjeuner des Canotiers is the
masterpiece by Renoir and finer than any Rubens—as fine as any
Titian or Giorgione." He continued, "Its fame is tremendous and
people will travel thousands of miles to our house to see it. It will do
more good in arousing interest and support for our project than all
the rest of our collection put together. Such a picture creates a
sensation wherever it goes." Phillips was right. The press reported
the price as $150,000; the *New York Herald* said it was "the highest
price paid for a painting by Renoir or for any other modern
painting."

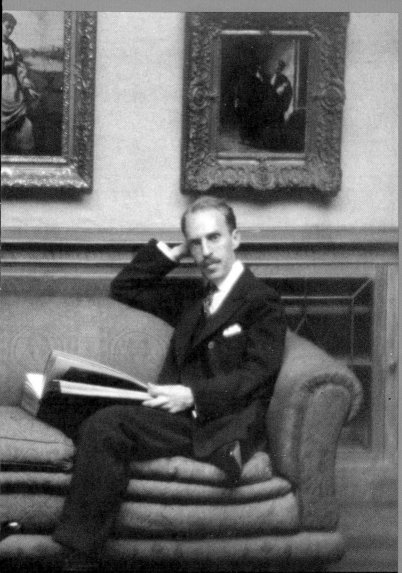

tings behind them include works by Jean-Siméon Chardin and Honoré Daumier.

The museum for which Phillips acquired the great Renoir was, and remains, idiosyncratic. Early plans for the Phillips Memorial Art Gallery included a traditional museum building; use of the house was intended as a temporary measure. Phillips's plans changed, however, partly because of economic factors, but largely because he recognized that an informal, hospitable setting better served his purpose of winning an audience for modern art. "To a place like that, I believe people would be inclined to return once they have found it and to linger as long as they can for art's special kind of pleasure," he wrote.

Phillips's anti-institutional display, bringing together works of different eras and nationalities, reflected his strongly held beliefs about art. Uninterested in strict chronology and the segregation of artists by school, he preferred to group their work for the purpose of "contrast and analogy. I bring together congenial spirits among the artists from different parts of the world and from different periods of time and I trace their common descent from old masters who anticipated modern times." Indeed, Phillips saw modern art as the continuation of a sort of uninterrupted visual conversation among artists, living and dead.

What could be more conducive to a visitor's awareness of these harmonious exchanges among artists than intimate surroundings? By turning a few rooms, and later the whole family house, into comfortably appointed galleries, Phillips created a series of salons where, to this day, the wordless interactions continue. As a good host, he saw to it that these conversations across time and continents sparkled by frequently rearranging the hangings. How fitting that he should have bought, as the great icon of his collection, Renoir's *Luncheon of the Boating Party*, one of the greatest conversation pieces of all time.

Party is a clear attempt to match the achievement of some of the old masters Renoir admired in the Louvre. Veronese (1528–88) and Watteau (1684–1721) particularly come to mind. The former's *Marriage Feast at Cana* with its intricate composition and bright,

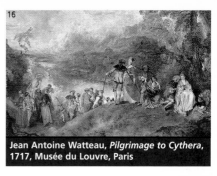

Jean Antoine Watteau, *Pilgrimage to Cythera*, 1717, Musée du Louvre, Paris

Venetian color harmonies may have contributed to Renoir's complex arrangement of figures around tables. But the work owes an even greater debt to Watteau's *Pilgrimage to Cythera*, a shimmering idyll of aristocratic dalliance. Renoir's *Luncheon of the Boating Party* can be viewed as a *fête champêtre* set in a modern industrialized world.

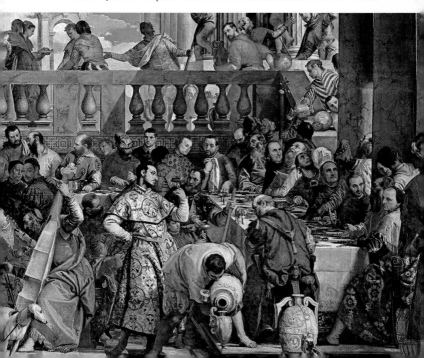

painting. Ephrussi and Laforgue, for example, were originally higher up on the canvas, and Ephrussi faced out towards the viewer. In the upper part of the painting, Renoir also reduced the original landscape portion of the painting, replacing it with the striped awning, thus containing the balcony space, sharpening the sense of depth, and concentrating the focus on the party.

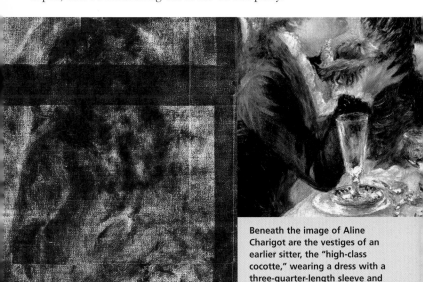

Beneath the image of Aline Charigot are the vestiges of an earlier sitter, the "high-class cocotte," wearing a dress with a three-quarter-length sleeve and holding a glass.

Above and below right: details taken from an X-radiograph of the painting

Jeanne Samary's green-brown hat was originally a lighter color. Traces of yellow and red paint suggest that she was wearing a straw hat in an earlier stage of the painting.

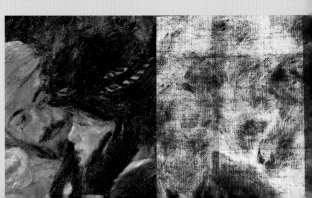

expected. Letters Renoir wrote during its execution testify to the delays caused by one model in particular, "a high-class cocotte," whom he eventually painted out. The compositional choreography of all the figures seems to have been done without the benefit of sketches and studies. Technical examination of the painting shows that Renoir moved figures around during the evolution of the

The heads of Laforgue and Ephrussi were originally set higher on the canvas. When the awning was added, the depth of the space increased, and Renoir moved them down to make the figures proportionally smaller.

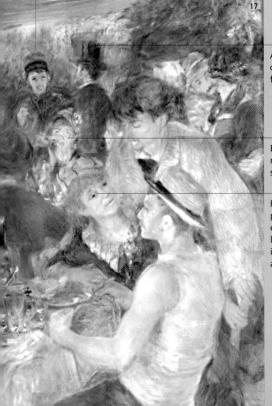

At an earlier stage of the composition, Ephrussi faced the viewer.

Ellen Andrée's head has been repositioned. A ghost image shows its earlier position.

Renoir moved the position of Angèle's eyes. Previously she looked out at the viewer instead of at the men around her.

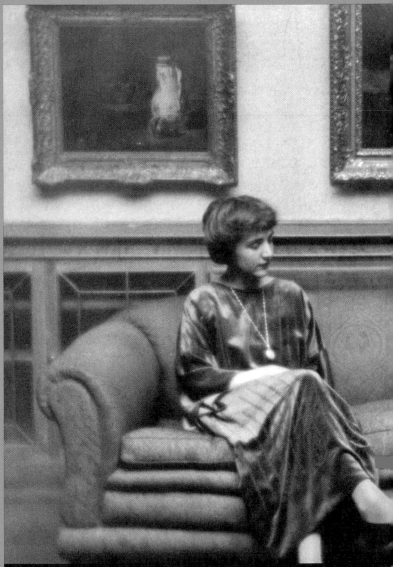

In June 1923, Duncan and Marjorie Phillips sailed to Europe. Over lunch at the Paris home of the art dealer Joseph Durand-Ruel, Paul's son, they admired a painting hanging in the dining room—the *Luncheon of the Boating Party*, "that fabulous, incredibly entrancing, utterly alive and beguiling Renoir masterpiece," as Marjorie Phillips later wrote.

Phillips had seen and loved the work before, in 1911. He wrote at the time, "There is an infectious good humor about his [Renoir's] work—a thrilling vitality in his vivacious raptures over modern life a group of Parisians lunching up the river on a hot holiday" He saw it again when Joseph Durand-Ruel brought the painting, along with other Renoirs, to New York in January 1923 for viewing only and not for sale. In Paris that summer Phillips opened

Above: Main Gallery, Phil and Maurice Prendergast

Duncan Phillips and Renoir's
Luncheon of the Boating Party

Luncheon of the *Boating Party* was well received on its completion. Renoir's dealer, Paul Durand-Ruel, bought it, quickly sold it, and soon afterwards reacquired it.

The painting remained in the hands of Durand-Ruel's firm until 1923 when, for a record-breaking price that made headlines, Duncan Phillips bought it. Phillips (1886–1966), heir to a Pittsburgh steel and banking fortune, was a passionate, discerning, and independent collector. His understanding of modern art took shape as much through his friendships with artists (among them his wife, Marjorie Acker, a painter) as through study. His taste in art developed with his collection over the course of a lifetime.

The Phillips family came to Washington in 1895 and soon settled there, building the residence that still houses The Phillips Collection. Duncan and his older brother, James, graduated from Yale University, with Duncan planning to be an art critic and James eyeing a political career. Always close, the brothers embarked on building a family art collection in 1916. The sudden death of their father in 1917 came as a major blow to Duncan, whose world reeled a second time, only thirteen months later, when James died of Spanish influenza. These devastating losses led Phillips and his mother to found a museum devoted to modern art and its sources as a fitting memorial to both men. Incorporated in July 1920, the Phillips Memorial Art Gallery opened to the public the following year in two rooms of the Phillips family home at 1600 Twenty-first Street, NW.